Mary Panzer

MATHEW
BRADY 55

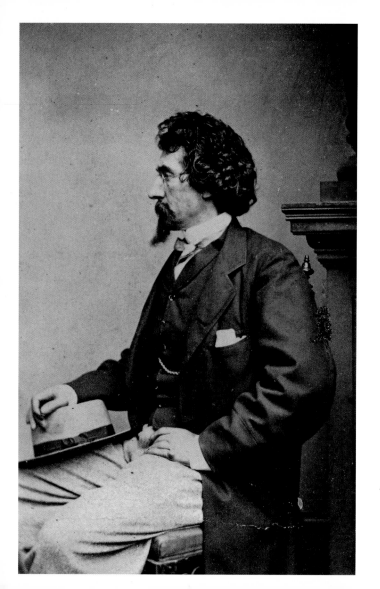

2.3

Mathew Brady is widely recognized as one of the most important photographers of the nineteenth century. But unlike other modern artists, he created no single masterpiece, nor can he be assigned full credit for a body of work, for he rarely operated a camera, or printed a negative. Brady used photographs in the way a director uses film, or a conductor uses an orchestra – to create a work through the labour of others, in his case, camera operators and darkroom technicians. His contribution to the medium, and to the history of mass culture, is embedded in the way in which we use and perceive photographic images. The modern institution of celebrity, for example, has its origins in Brady's ability to turn famous names into famous faces, and to place them before an audience far larger than any single auditorium or parade ground could hold, first by turning his studio into a national institution, and then by disseminating his work in the pages of a new kind of publication, the illustrated magazine.

Brady's innovations combine with his ability to incorporate conventions of the past; his sitters stand in a bare studio against a velvet drape that recalls the portraiture of old masters like Rembrandt, or Van Dyck, their hands shoved between the buttons of a waistcoat, as David posed Napoleon. But these are clearly citizens of the nineteenth century, with plain gabardine coats and beaver hats, the women adorned in lace, striking a sure, graceful balance between the classical signs of heroism and the prosperity that modern America recognized as a virtue.

At the end of his career, Brady even found ways in which to transcend the limits of time by trading his stature as an artist for that of a historian, making it possible for his subjects to address posterity by securing their connection to a heroic national narrative. Like Benjamin West, Brady took artistic convention

onto the battlefield. Because he worked in photography, not oil paint, his soldiers still look familiar and real today, and his monumental compositions are classed as documents. Brady's most important legacy, then, lies both in the impossible beauty of his celebrity portraits, and in the creation of a durable myth of a war waged by giant leaders and brave young men in the service of a just cause. In short, Mathew Brady discovered how to use a camera to tell true lies.

Brady's story is joined to that of photography in the nineteenth century, from his beginnings with daguerreotypes in the 1840s, through ambrotypes and wet-plate negatives printed on salted paper in the 1850s, to shiny albumen prints in the 1860s, single images, stereographs and cartes-de-visite. Whether motivated by genius, ambition or simple greed, at every step Brady's career was distinguished by an ability to exploit new technology to reach the largest possible audience. His flair for publicity rivalled that of P.T. Barnum, his colleague and close neighbour on Broadway, with whom he worked to promote the wedding of the midget Charles S. Stratton, better known as Tom Thumb. By 1845, Brady had turned his studio into a tourist destination, and a portrait by Brady had become synonymous with fame. In 1860, Edward Prince of Wales, the first British royal ever to visit the United States, posed for a photograph by Brady.

From the first, Brady arranged to translate his daguerreotypes into lithographs and steel engravings for distribution through print shops. His photographs were also copied onto woodblocks, which could be set alongside type to create popular illustrated publications such as *Harper's* and *Frank Leslie's Illustrated Magazine*. Brady also worked closely with artists to make large, accurate, life-like painted portraits, which were exhibited in his studio. With the arrival of the carte-de-visite, the first form of photography that could be easily produced and

sold in large numbers, Brady recognized that his negatives had acquired new value. Working in partnership with photographic publisher E. and H.T. Anthony, Brady sold thousands of tiny portraits of famous sitters, including the President, politicians, performers, writers, businessmen and many women known mostly for their wealth and beautiful attire. The Anthonys in turn published millions of portraits with prominent credit to Brady and his 'National Portrait Gallery', as he called his studio, which was perceived as a sign of authenticity.

When the Civil War broke out in 1861, Brady took payment from the Anthonys in the form of supplies – cameras, glass plates, photographic paper and the chemicals necessary for making photographic negatives, in order to support teams of photographers who followed the Union Army. Brady's photographers made countless portraits; after all, any soldier, of whatever rank, could become the next national hero (or martyr) whose picture would be in great demand. Once on the field, Brady's photographers discovered a wide range of subjects never seen before, and certainly not depicted by modern American artists.

But at the end of the four-year war, Brady's romance with the public abruptly ceased; he found himself burdened with debts, owning thousands of glass negatives recording soldiers and scenes of a battle that no one wanted to remember. Unable to pay his storage bills, Brady lost part of his archive to junk dealers, and sold other parts to collectors, to publishers and finally to the US government. He would have to wait for the end of the century, and the last years of his life, to find a new audience among those who had no first-hand knowledge of the events he claimed to represent. In the 1890s, when halftone technology allowed publishers to reproduce photographs cheaply and well, they turned to

Brady's archive and found an endless resource of pictures exactly suited to nostalgic accounts of war – full of specific, concrete detail, endowed with Brady's trademark heroic glow.

The precise place and date of Mathew Brady's birth are unknown and perhaps unimportant, for Brady's life truly began in the early 1840s when, like thousands of others, Americans and immigrants alike, he came to New York City in search of the 'main chance'. During the first two decades of his career, roughly 1840 to 1860, New York grew from a city of 312,000 to a metropolis of 814,000, transforming from a busy provincial port into an international centre of finance and culture. With its chaotic traffic, towering buildings, glittering shops, theatres, bars, restaurants and unending crowds, New York often reminded visitors of a kaleidoscope, full of whirling unpredictable patterns. It was a place where old-fashioned education and skills of the past proved far less useful than luck, ambition, a sharp eye and a love for the present, the immediate, the new.

Running north from the City Hall to New York's northern boundary, Broadway was the commercial and social centre of the city, site of all important civic spectacles, from election parade to funeral procession. Along Broadway, one could glimpse every important and exotic visitor, every noted politician, every powerful man and beautiful woman in America. For New Yorkers and many others, Broadway was also the heart of the nation, far more varied, and more exciting, than the political capital in Washington. Brady's first studio stood on Broadway, opposite City Hall, and as the growing city pushed north, he took new rooms, moving four times between 1844 and 1860. 'Find the photographic emporium of our friend Brady and you find the spot where the city of New York is liveliest,' declared the journalist Nathaniel Parker Willis in *Home Journal*, 1859.

Brady's ability to use his camera to turn his sitters, and himself, into modern national celebrities arose directly from the character of this time and place.

The daguerreotype was unveiled in Paris in 1839 to great acclaim, and from the start Americans displayed a special affinity for the medium. By the 1850s, every large city in America had several daguerreotype studios. In big cities like New York, Boston and Philadelphia, daguerreotypists organized clubs to provide, support and spur competition. Around the nation, subscribers to professional journals traded business tips, chemical formulas and artistic advice. In New York alone there were dozens of daguerreotype makers, as well as importers and manufacturers of cameras and chemicals. Though many daguerreotypists worked alone, mid-century accounts also describe large studios that employed many specialized workers, including young boys who polished and prepared the plates; a camera operator who made the exposure; technicians who manipulated chemicals and mercury fumes to develop the image; colourists (often trained artists) who added touches of pink to cheeks and gilding to jewellery and watch chains; and the finishers who covered the fragile portraits with glass and sealed them in a leather case. The proprietor ran the business, greeted his customers and directed the making of the portrait. Brady and his studio quickly won popularity with the public, and recognition among his peers. They admired the artistry of his portraits, the relaxed dignified faces of sitters, and his skilful use of light and shadow, which made his figures seem to stand out from the surface of the plate like a sculptural relief.

These shiny, detail-rich pictures seemed to meet the needs of Brady's contemporaries, men and women who measured success in concrete terms. The portraits were up-to-date, relatively inexpensive and very effective in securing

a likeness. In another way, Brady's generation used these images to address a problem that was both abstract and very real – namely, the need to define the national character. In 1850, the United States was just seventy-five years old, its first, revolutionary citizens were gone, and the men who had known them were dying out. Brady's sitters sought ways to identify themselves and their country, and when they looked at a daguerreotype, they liked what they saw. In the style of the time, all art was treated as allegory, and every public achievement was interpreted as an episode in a larger national narrative. Visitors came to Brady's National Portrait Gallery to inspect the faces of politicians, writers, actors, publishers, lawyers, military leaders and businessmen, whose names were well known, thanks to an ever more vigorous press. No other single room could hold such a large crowd of important people – it almost seemed as if the gallery contained the nation within four walls.

Despite his growing fame, Brady was not content. He constantly looked for ways to exhibit his work beyond Broadway. Because daguerreotypes are unique images and have no negative, they can be copied only by an artist working by hand, who would transfer the image onto a copper plate. Daguerreotypists regularly sold their work to engravers, who turned the silver images into commercial prints. Unlike most of his colleagues, Brady always received credit for his work, and the inscription 'From a Daguerreotype by Brady' became a guarantee of both accuracy and art. In 1850, Brady started his own publishing venture, hiring lithographer Francis D'Avignon to make prints from his portraits of famous sitters such as naturalist J.J. Audubon, war hero Winfield Scott and President Zachary Taylor. He sold the prints by subscription and called the collection 'The Gallery of Illustrious Americans'; but the project folded after twelve issues. In 1851, he reached an international audience when

he won a medal at the Fair of all Nations in London, commonly known as the Great Exhibition.

In Britain, during 1851, Frederick Scott Archer found a way to use the transparent albumen in egg whites to attach a light-sensitive formula to glass. When exposed in the camera, developed and dried, the result was a negative image that could be placed directly against light-sensitive paper to create a new positive, a 'photograph'. The neologism combined the Greek terms for 'light' and 'writing'. Because this solution remained sensitive only while still damp, all negatives had to be prepared on the spot and the process was commonly known as 'wet plate'. At first, photographs were the same size as the negative from which they were made. Brady's studio used wet plates to produce photographs as early as 1854, and by 1855 he advertised 'Brady Imperials', made from negatives roughly 24 inches tall and 20 inches wide. The 'Imperials' were beautiful and dramatic, as large as some paintings. By 1860, innovators had developed a process to enlarge images, enabling Brady's technicians to produce portraits that were truly life sized. He began to underscore the qualities that his work shared with traditional art, filling the background of his portraits with classical props, such as fluted columns and damask drapes. As always, he lit his subjects with care. He revelled in the freedom these large images offered his sitters, who frequently assumed poses that included some distinctly personal gesture, or revealed a characteristic expression. Brady achieved these results with exposures that lasted for about fifteen seconds, lengthy by today's standards, but quick enough to capture a smile.

During the 1850s and 1860s, Brady worked closely with a group of artists centred around Samuel F.B. Morse. Best known today as the inventor of the dot-

and-dash code that was used to send messages by telegraph, Morse spent much of his life in New York as an artist and teacher. Science-minded and creative, Morse encouraged his students to make use of new technology, and many relied on photographic images, especially when making portraits. Brady often collaborated with these painters. On many occasions, he posed sitters according to directions supplied by the painter, who used the resulting photograph as a preliminary study, or sketch, for the finished canvas. After the death of Abraham Lincoln, many painters turned to photographs for memorial images, often choosing portraits made by Brady. Though little discussed today, this technique was quite common in the middle decades of the nineteenth century, when popular taste in painting favoured highly realistic effects. Brady himself employed painters, who added 'enhancements' to his photographs in ink, watercolour and oil paint. By applying ink, artists could make unruly hair smoother, help jackets lose their wrinkles, make large feet smaller and wide waistlines grow slim. With oil paint, photographs could be turned into colourful paintings, the soft paper surface becoming slick like enamel. Occasionally, enhancement also included additions to the background, so that the subject appeared to pose amid flowers. While an endless argument raged over the true status of photography, Brady and his colleagues collaborated on images that defied easy classification. His clients recognized these enhanced images as photographs, while many photographers, Brady included, declared themselves artists.

In 1856, Brady hired Alexander Gardner, a photographer and Scottish immigrant who had mastered the new method for making wet-plate negatives. Two years later, he opened a second branch of his studio in Washington DC, and put Gardner in charge. As he had in New York, Brady placed his studio at the centre of town, halfway between the Capitol and the White House, close to the

busy Willard Hotel. By the end of the 1850s, Washington politicians had become essential to Brady's National Portrait Gallery. A complex and increasingly violent debate filled the headlines as the Southern slaveholding states struggled to maintain power and a way of life. Actual warfare broke out in the western territories, where factions fought to control the status of slavery when new states joined the Union. In Washington, citizens filled the galleries of Congress to hear debates between Democrats, Whigs, members of the new Republican party, opponents of slavery, supporters of slavery, and most importantly, to hear the battle over the survival of the Union as Southern politicians argued for the creation of an entirely new country where slavery would be legal. Brady sold his portraits of star orators to illustrated journals, who reprinted speeches and covered the unfolding story for the nation. Visitors to Brady's Washington gallery saw the collection itself in historic terms. The variety of views represented at Brady's inspired one journalist to imagine that if these men could unite 'in as calm a frame of mind as their pictures were, how vastly all the world's disputes would be simplified, how many tears and troubles might mankind still be spared!' Others, such as the *American Journal of Photography* of October 1860, saw the gallery in terms of posterity, a record for unborn generations showing 'what manner of men and women we Americans of 1860 were'.

Alexander Gardner was an excellent businessman, and under his direction Brady's Washington studio ran at a profit. He was aided by an important new technological development, imported from France: the carte-de-visite. Invented in Paris in 1859, these portraits were the size of the visiting cards that gave them their name. They were produced by making a simple adjustment in the camera: where ordinary cameras used one lens to expose a single image onto a plate, the new camera had four lenses, which in turn exposed four small images,

and the resulting negative plate printed a quartet of pictures. These were then cut apart, mounted on cards, and sold by the dozen. This innovation made photography a true mass medium. Inexpensive, attractive and novel, cartes remained immensely popular for nearly a decade, and were printed by the millions. This truly democratic form of portraiture was equally attractive to Napoleon III, the President of the United States or the most ordinary middle-class citizen. Families collected pictures of loved ones in special albums, to which they often added carte portraits of famous figures. As celebrities and politicians came to Brady's gallery, he acquired negatives of the best-known figures in America; and he copied portraits of other well-known sitters into the new small size.

Brady's studio eventually sold thousands of carte negatives to the commercial photographic company of E. and H.T. Anthony, who published millions of these portraits, stamped on the verso with a bold advertisement for Brady's National Portrait Gallery. Near the end of his life, a reporter observed that the 'notoriety' of his sitters must have prompted enormous sales. Brady concurred in *Still Taking Pictures: Brady Grand Old Man of American Photography* (1891), stating that 'Of such men as [Union General U.S.] Grant and [Confederate General Robert E.] Lee, at their greatest periods of rise or ruin, thousands of copies [were made].' In a revealing passage he added, 'all that sort of work takes rigid, yes, minute worldly method. My energies were expended in getting the subjects to come in, in posing them well and in completing the likeness.'

In the spring of 1861, shortly after Abraham Lincoln became President, the Southern states united to form the Confederacy and seceded from the Union. When South Carolina soldiers fired on a military fort in Charleston harbour, civil

war began. Brady quickly realized that headlines would come from the battlefield, not in Congress, and he adjusted his method in order to pursue the military men whose faces would become famous. Though Brady's studio eventually produced thousands of negatives that preserve a priceless record of military life, nothing like it had been done before, and he had to resist strong opposition. 'My wife and my most conservative friends had looked unfavourably upon the departure from commercial business to pictorial war correspondence, and I can only describe the destiny that overruled me,' he recalled in *Still Taking Pictures*. 'A Spirit in my feet said, "Go", and I went. After that I had men in all parts of the army, like a rich newspaper.' Brady equipped teams of photographers with wagons that contained everything they needed to make photographs – cameras, glass plates, chemicals and a dark tent. They followed the army and made thousands of portraits; tree stumps and camp chairs took the place of studio columns and pillars, tents and fields filled the background.

Once they left the studio, Brady's photographers found new, essentially modern subjects. Though the cumbersome wet-plate process was too slow to record action, their portable wagons made it possible to record battlefields after fighting had ceased. War makes heroes without respect to rank, and Brady's photographers spent most of their time photographing groups of soldiers, never knowing who might be the next martyr. An excellent example was that of Elmer Ellsworth, the first Union soldier to die, whose martyred face appeared everywhere thanks to the portrait he had made at Brady's studio a few days before he fell victim in a casual skirmish. Over four years, Brady's operators produced many thousands of portraits of ordinary men and boys in uniform, and established a new view of warfare that was a chilling contrast to the elegant portraits of generals and admirals that Brady expected to add to his gallery.

Alexander Gardner headed the team that photographed the aftermath of the Battle of Antietam in 1862, one of the bloodiest of the entire war. When his photographs of bloated bodies shocked viewers, Brady apparently instructed his workers to retreat, for thereafter they produced much more conservative, patriotic documents. Gardner soon left Brady to establish his own business and continued to photograph the war as he saw it, taking many of the best photographers with him. Brady remained loyal to his old, patriotic vision. Where Gardner and his workers photographed the bodies of dead soldiers, as they did after the Battle of Gettysburg in 1863, Brady and his team arrived a few days later to make an elegiac view of the famous battlefield. Doubtless, Brady's audience could easily fill the image with vivid associations, but without knowing the story to which it refers, modern audiences see only a picturesque image of a fence, pond and field.

Though Brady's debts were large, he anticipated that the flush of sentiment ensuing from the inevitable victory of the Union would ensure the value of his archive, which exceeded 10,000 negatives. Within a few weeks, in the spring of 1865, the whole tragic era came to an end; Lincoln was inaugurated for a second term in early March, Confederate General Lee surrendered in early April, and less than a week later, Lincoln was assassinated by Southern sympathizer John Wilkes Booth. Then, to his surprise, Brady found that no one wanted his portraits of soldiers and politicians. Before the war, his visitors had commended his collection for its historic associations; now, the same faces seemed sad and stale. For nearly ten years, Brady campaigned to sell his collection, while his fortunes declined. In 1872, he declared bankruptcy, closed his New York gallery and stored his negatives in a warehouse; he lost thousands of images when he failed to pay the storage bill, and one plausible legend holds

that some glass plates were eventually used to build greenhouses. Finally, in 1875, he successfully sold thousands of daguerreotypes, photographs and negatives to the US War Department for $25,000 (equivalent to several million dollars today). Beginning again, and opening a series of studios, Brady decorated their walls with a collection of his most important pictures, and waited.

Recognition finally came from a new generation who had no bitter recollections of the war. Through Brady himself, they could touch the man who preserved vivid portraits of the most dramatic figures of the nation's past. His photographs made it possible to stand face to face with history. Publishers eager to profit from the building wave of nostalgia for this glorious past turned to Brady for illustrations and found pictures to fit the history they wanted to write. A century later, in 1946, historian Arthur Schlesinger Jr confidently observed that 'we think of the Civil War in Brady's terms'.

Mathew Brady's greatest legacy lies in his understanding of the way in which a photograph can come to replace the subject it claims to represent. From artists, he learned how to compose good pictures, how to 'enhance' and manipulate content with light and shadow as well as with the addition of actual paint and colour. He sold his photographs for reproduction because he recognized that he was the author of an image that could survive all translation – into lithograph, or woodcut, or painting – and his insight is confirmed in the compelling photographs that still fill today's documentary films and glow on the video screen. As Brady mastered this process, he also transformed himself from portrait artist to national historian. His discoveries led to the invention of modern celebrity as well as to the dramatic story-telling pictures that we know today as photojournalism.

Thomas Cole (1801–48), New York, 1846. Thomas Cole was one of the best-known painters in New York City when Brady made this portrait. His most famous work used local landscape to support moralizing allegories, many of which warned against the dangers of modern materialism. Brady did not share his sitter's vision. He thrived in New York's chaotic, commercial culture. From his arrival in New York in the early 1840s, Brady pursued clients like Cole, knowing their fame would ensure his own. Here, he wrapped the painter in a velvet cloak that alludes to his profession and his devotion to classical civilization.

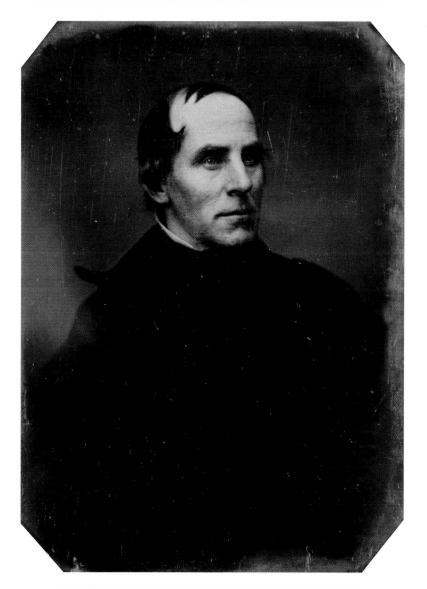

Cornelius Mathews (1817–89), New York, c.1846. In 1853, Cornelius Mathews published *A Pen and Ink Panorama of New York*, a guide for the many immigrants and visitors who came to the city, drawn by its air of glamour, danger and opportunity. Mathews took a sophisticated view of the city's riches. For him, the commercial street, Broadway, was like a 'great sheet of glass through which the whole world is visible'. By 1853, Brady's National Portrait Gallery had become one of Broadway's noted landmarks, thanks to his daguerreotypes, which allowed visitors to stand face to face with the famous – or the would-be famous like Mathews himself.

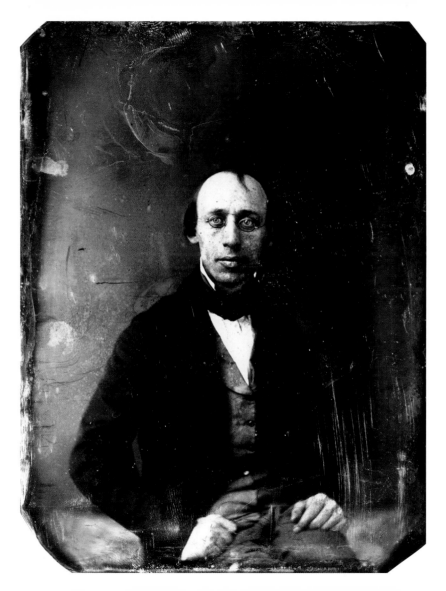

Asher B. Durand (1796–1886), New York, c.1846. Asher Durand led a group of artists and writers who strived to form a culture distinct from the Old World. They often chose landscape as a subject, since the United States had none of Europe's ruins or castles. Durand painted his densely detailed views of rocks and trees in the open air, and maintained rigorous fidelity to atmosphere and light. Here, Brady directed light on Durand's high forehead and focused his eyes on some distant scene, as if staging a moment of inspiration for the camera, and for posterity.

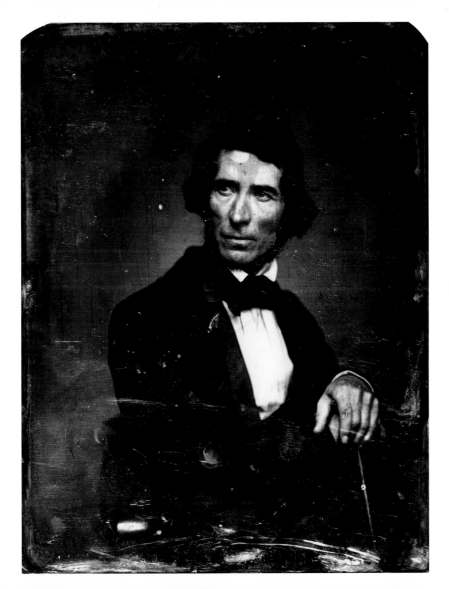

Henry Inman (1801–46), New York, c.1845. Inman was a portrait painter, a commercial artist and a publisher, who successfully issued many portrait prints of performers, politicians and historical figures. His enterprise foreshadowed the work of Brady and other photographers, whose cameras replaced the many engravers and copyists required to turn a single painted image into a plate from which hundreds of identical prints could be made. This daguerreotype was reproduced in the form of a woodcut, illustrating a laudatory essay on Inman's work. Inman must have known that this fashionable patterned waistcoat would add graphic power to his portrait.

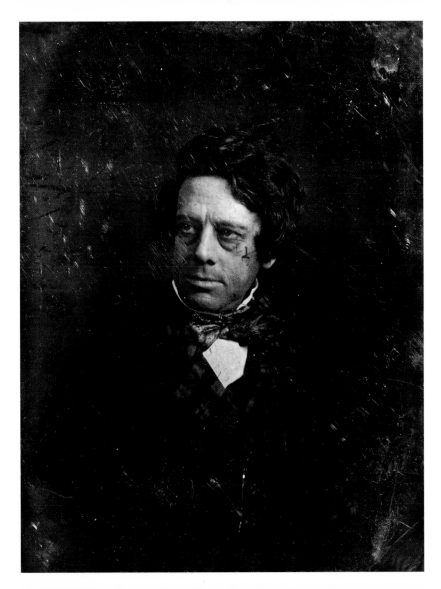

Shepherd Knapp (1795–1875), New York, c.1845. Shepherd Knapp was a leading citizen of New York, a bank president, political leader and a supporter of national industrial fairs that awarded medals in recognition of American innovation and enterprise. Knapp was a typical figure in Brady's National Portrait Gallery, a man who would be recognized on sight by his contemporaries, but whom they might rarely meet. His relaxed expression and easy demeanour provide evidence of Brady's distinctive ability to make sitters comfortable before the scrutiny of the lens.

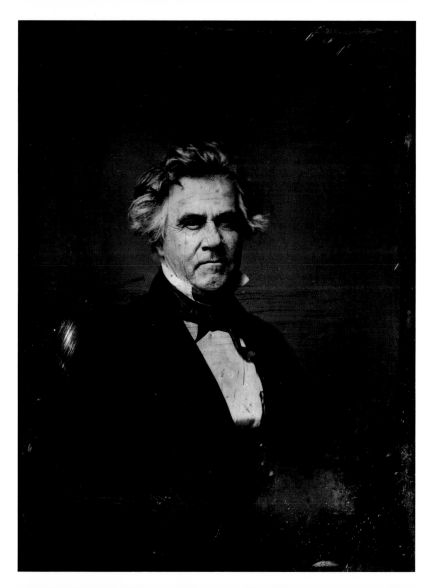

James Henry Duncan (1793–1869), Washington DC, 1849. In 1849, Brady came to Washington to photograph new President Zachary Taylor along with many other politicians, including Col. James H. Duncan, a Massachusetts Congressman who posed in his militia uniform. From the 1830s onward, many critics recognized the daguerreotype as the medium best suited to represent American style and culture. Certainly it made a splendid record of Duncan's elaborate curls and shining buttons. It is also tempting to read a sly judgement of character in this merciless rendering of one man's rigid adherence to high fashion.

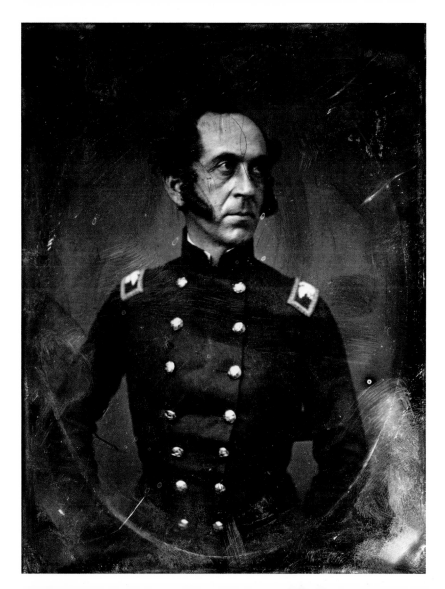

Francis Bicknell Carpenter (1830–1900), New York, c.1850. For several months in 1863 and 1864, Francis Carpenter lived in the White House while gathering studies for a portrait of President Lincoln. He eventually produced a wooden tableau that shows Lincoln in a room full of colleagues, their precisely rendered faces clearly copied from photographs. In fact, many artists came to Brady for such records, a service he happily fulfilled, even posing sitters according to the artist's instruction. Though an indifferent artist, Carpenter produced a lively memoir, *Six Months at the White House*, full of anecdotes about Lincoln's daily life during the Civil War.

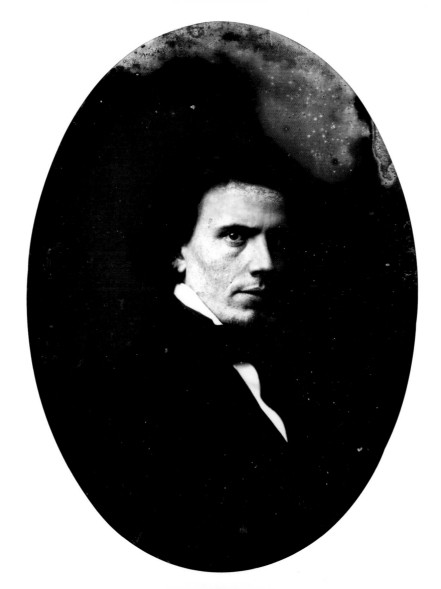

Rembrandt Lockwood (1815–after 1889), New York, c.1850. In 1845, aspiring artist Rembrandt Lockwood left America for Munich, where he studied the work of the Old Masters. Two years later, he returned to New York and began to specialize in genre painting and religious art. By 1858, he had turned to architecture and designed numerous churches throughout the region. This portrait was made around the time of Lockwood's European sojourn. Today, with his velvet-collared cloak and intense gaze, Lockwood seems to epitomize the Romantic, self-conscious artist – though we cannot know whether this was his intention, or Brady's, when the portrait was made.

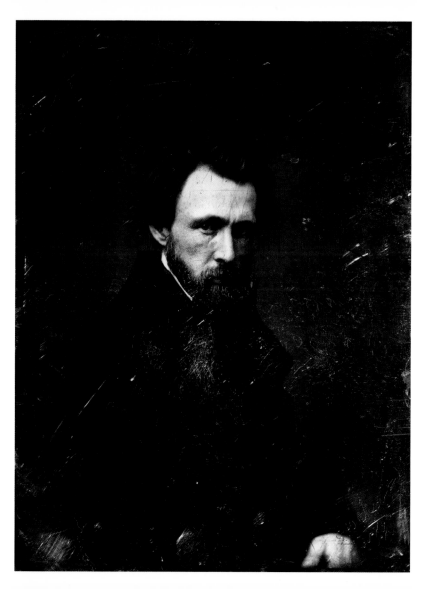

Unidentified Woman, New York, c.1850. Brady placed all the portraits of women together in what one reporter called 'the best portion of the gallery', where crowds of sightseers could inspect the attire, coiffure and expressions of the wives of famous men. Brady's fondness for the good life was well known; he also understood how to arrange his sitters so that their costly velvet, ribbons, lace and jewellery could best be rendered on the shiny daguerreotype plate. Here he assembles the many intricate details of a young woman's finery into a charming record of youthful luxury and wealth.

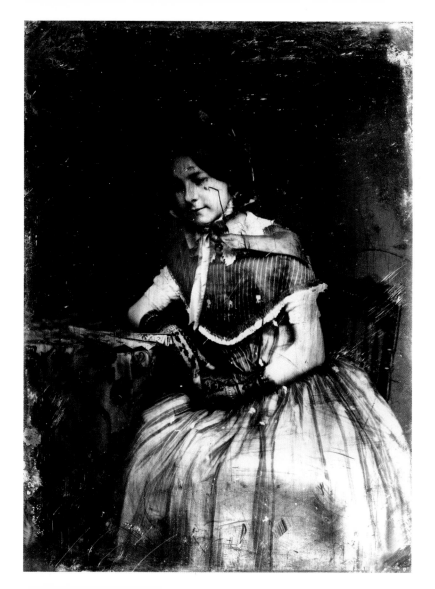

Anonymous Woman, New York, c.1850. In 1860, Brady moved into his final Broadway gallery. One reviewer remarked that many of his images, now fifteen years old, were no longer records of the present, but pieces of the past. In these photographs, Brady provided 'the means by which we shall bequeath to our posterity of knowing what manner of men and women we Americans of 1860 were. All our books, all our newspapers, all our private letters ... will not so betray us to our coming critics as the millions of photographs we shall leave behind us ... our children's children may look into our very eyes and judge us as we are.'

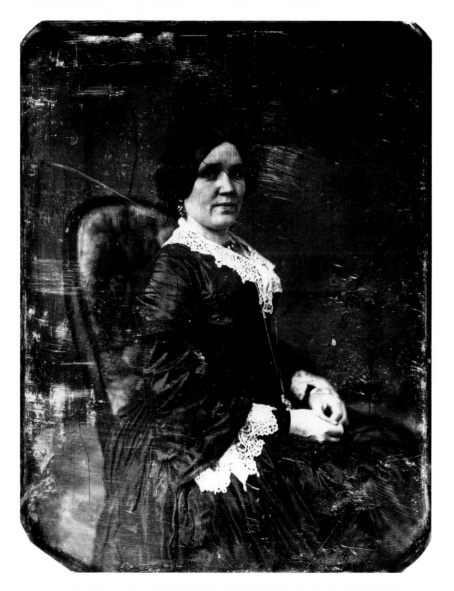

Forbes B. Winslow (1810–74), London, England, 1851. In 1851, while in London to visit the Great Exhibition, Brady continued to seek out famous sitters. Among them was Dr Forbes B. Winslow, a physician who specialized in treatment of the insane, and founder of the first British *Journal of Psychiatry*. Posed at a table with a quill pen in hand, he seems to have paused in the midst of writing. This delicate piece of stagecraft allowed Brady to make a lively, convincing picture without risking the distracting blur that would come from the motion of a moving pen.

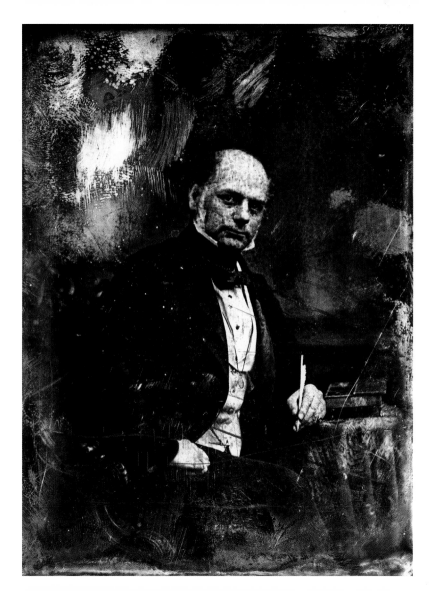

Mathew Brady, with Juliette Handy Brady (1822–87) and Mrs Haggerty (life dates unknown), New York, 1851? Like most events in Brady's life, the facts surrounding this portrait of the photographer, his wife and sister remain uncertain. It was taken around 1851, about the time the Bradys married and sailed to London to visit the 'Exhibition of the Industry of all Nations', where his work was on display. This pleasant group portrait demonstrates Brady's great skill in manipulating light, choosing a pose and endowing his sitters with confidence which earned praise from the public and from his fellow daguerreotypists.

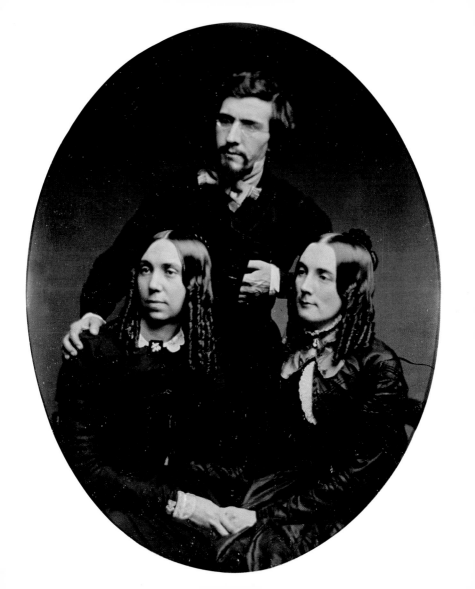

Mrs Gabe Harrison (dates unknown), New York, c.1856. Brady photographed Sarah Stevenson Harrison and her children in New York in the late 1850s. Her husband, Gabriel Harrison, was one of Brady's most distinguished competitors, a daguerreotypist, artist, playwright and close friend of Walt Whitman. This is one of relatively few domestic group portraits that appear in Brady's archive. Mrs Harrison's graceful pose, the direct gaze of her daughter and their elegant attire all recall the work of French painters Edouard Manet and Edgar Degas, Brady's rough contemporaries who often relied on photographic images. No evidence suggests that Brady knew their work. The resemblance can be plausibly attributed to the power of international fashions in costume, portraiture and photography.

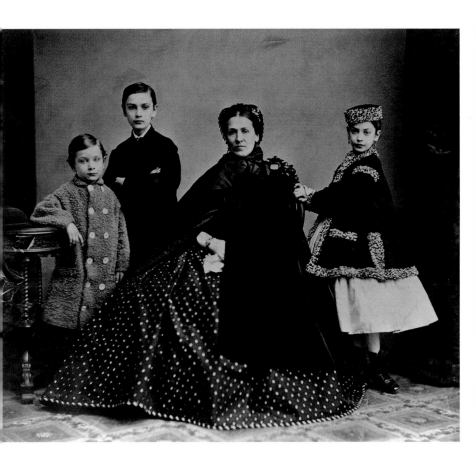

Thaddeus Hyatt (1817?–1901), New York, c.1857. Affluent, flamboyant and a committed abolitionist, Thaddeus Hyatt took a prominent role in the bloody fight over the status of slaves as the new state of Kansas joined the Union. This portrait, converted to woodcut, accompanied many accounts of Hyatt's activities as publicist for the Free State, including one disruptive speech before Congress that landed him in jail. Hyatt's long hair and arrogant posture allude to his identity as a western pioneer. His presence in Brady's collection underscores the broad range of achievement – and notoriety – that earned admission to Brady's National Portrait Gallery.

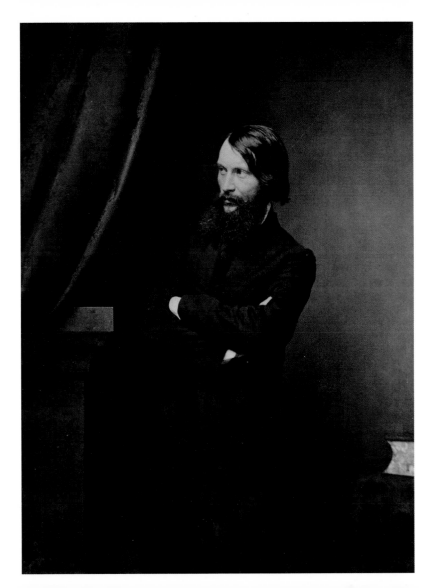

Jack Hayes (1817–83), Washington DC, c.1857. Jack Hayes claimed to have introduced the Colt revolver to the western frontier. In the 1840s, as leader of a band of 'Texas Rangers', he waged an independent war against Mexicans and Indians. After the Mexican-American war ended in 1848, he travelled to California, joined the Gold Rush and amassed a fortune in real estate. This portrait is an excellent example of a 'Brady Imperial'; the careful use of light places Hayes' confident figure within a deep, luminous space, and animates his expression, filling the figure with life. Brady's studio never surpassed the formal beauty of the images he made in the late 1850s. He seems to have been inspired equally by the large negatives, the lush, dark paper prints and the dynamic, adventurous men and women who came to his studio.

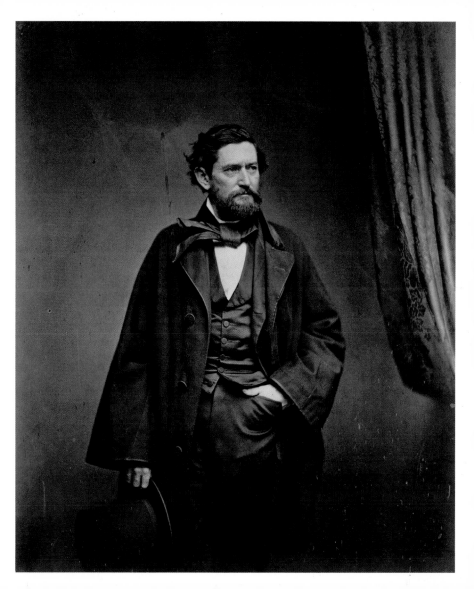

Madame de Trobriand (dates unknown), New York, c.1857. Mary Mason Jones, daughter of a New York banker, married Philippe Regis Denis de Trobriand in Paris in 1843 and soon returned to New York, where they remained influential members of society until the end of the century. Brady's audience often read faces for signs of national character. Madame de Trobriand might have been the matron one reviewer called 'mainly French', though 'the archness which pervades the features is decidedly American, more full of pleasing expression than of striking beauty'. Then as now, fashion was a popular subject and Brady obliged his audience with a full-length view of the subject and her elaborate attire.

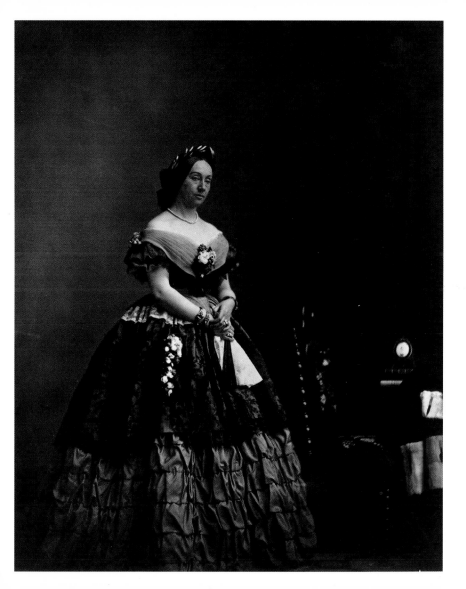

John Henry Hopkins (1792–1868), New York, c.1857. Lawyer and architect John H. Hopkins was the presiding Bishop of the Episcopal Church of New York when this portrait was made around 1857. The entire composition, from lighting and pose to expression, alludes to the conventions of the painter's studio. Here, Brady's operators use the skylight illumination to enhance the beatific aspect of Hopkins' white hair and beard. But the audience expected truth from photographs, and their assumptions helped mask such manipulation, which would have been far more obvious in painted form.

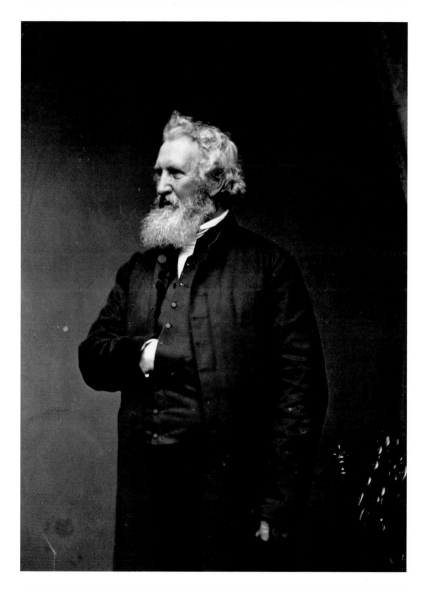

Mary B. Matthews Moffat (dates unknown), New York, c.1857. Mary Matthews Moffat, wife of James Clement Moffat, a Princeton professor, embodies the 'glossily ringletted and monumentally breastpinned' women that filled New York City in the 1850s, when Henry James, future novelist, was a boy. James and his father also posed for Brady's camera, and their photograph inspired James to begin writing his own autobiography. Seeing this world through modern eyes, James asked, 'Was it all brave and charming, or was it only very hard and stiff, quite ugly and helpless?' He knew that the answers were far less important than the questions Brady's images inspired.

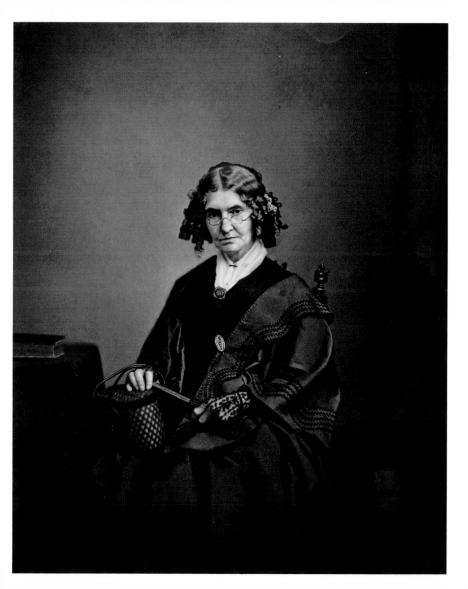

Celeste Revillon Winans (dates unknown), Washington DC, 1858. In 1847, in St Petersburg, Celeste Revillon, a young French-Italian aristocrat, married American engineer Thomas Winans, who was in Russia with his brother to supervise construction of a railroad to Moscow, a project that made them millionaires. Four years later, Celeste and Thomas Winans returned to America. This portrait was made after 1856, when Brady began to produce large Imperial photographs, rivals to painted portraits in both size and allure. Brady's operators knew how to use light and pose to reveal metaphorical significance in the texture of everyday life: Mrs Winans' sleek coiffure, velvet jacket and silk skirt have become a subtle essay on exotic sophistication.

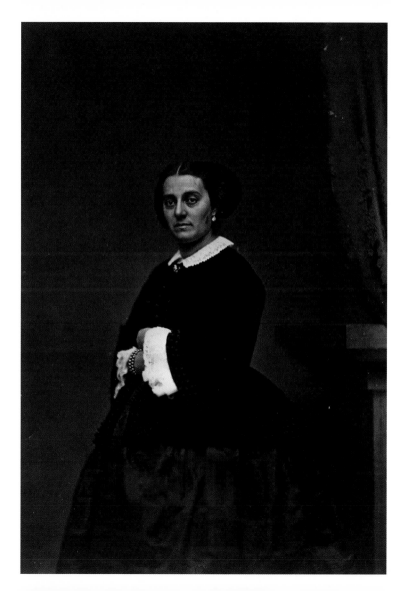

Robert W. Weir (1803–89), New York, c.1859. Friend to Asher B. Durand, Thomas Cole and Samuel F.B. Morse, for many years Weir taught drawing and drafting at the United States Military Academy at West Point, and was widely praised for his large colourful tableaux depicting important events in the nation's past. Brady may have had Weir in mind when he imagined that his archive would be valuable to history painters of the future, since they represented the important events of nineteenth-century America.

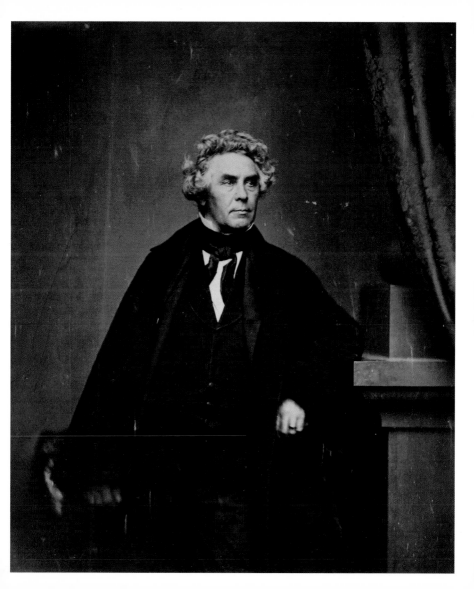

Thomas Ustick Walter (1804–87), Washington DC, c.1859. In 1850, Thomas Walter designed a badly needed extension to the US Capitol, adding two neoclassical wings and the now familiar cast-iron dome to create the monumental structure we know today. Brady photographed Walter around 1859, when the first phase of the building was complete. Here, the classical column provides an allusion to Walter's profession, while also signalling the imperial ambitions of both the architect and the nation he served.

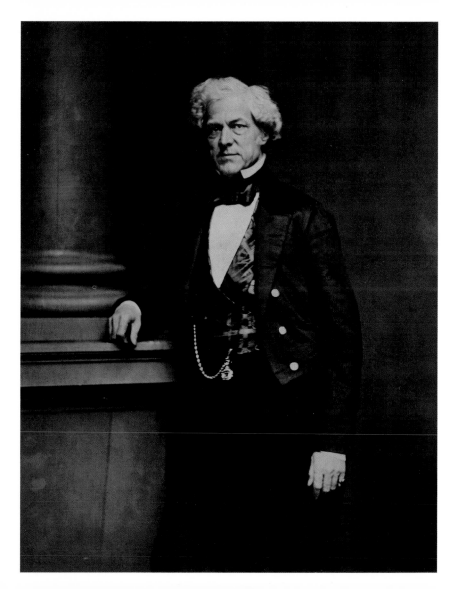

Abraham Lincoln (1809–65), New York, 1860. Brady first photographed Lincoln in New York on 27 February 1860, the day he addressed a Republican gathering at the Cooper Institute, a popular speech which introduced him to the nation. Brady's artists made their usual ink and watercolour 'enhancements' to this portrait, smoothing unruly hair, removing lines from the face. The enhanced portrait was then rephotographed to create a small new negative from which many cartes were produced. This image also appeared in posters and woodcuts throughout the presidential campaign. After Lincoln won the election and moved into the White House, legend says he observed that 'Brady and the Cooper Institute made me President'.

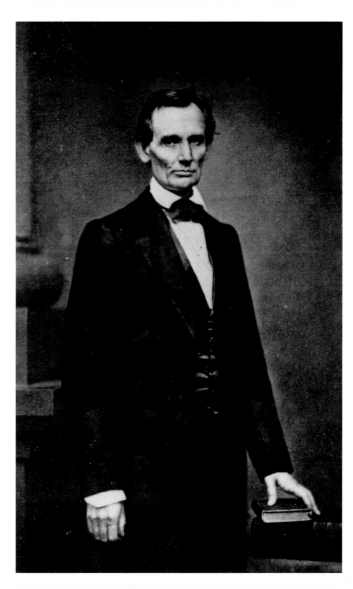

Edwin Forrest (1806–72) as Spartacus, New York, 1861. From the 1820s until the Civil War, Edwin Forrest remained a popular fixture of the American stage. His large, physical style was closely identified with the national character, and his loyal fans came from the working class. In 1861, Forrest commissioned Brady to photograph him in costume as he performed his most famous roles, such as Spartacus, hero of *The Gladiator*. It is likely that Brady designed this image to accommodate additions by studio artists, who would finish the photograph by painting in an elaborate background, often in colour.

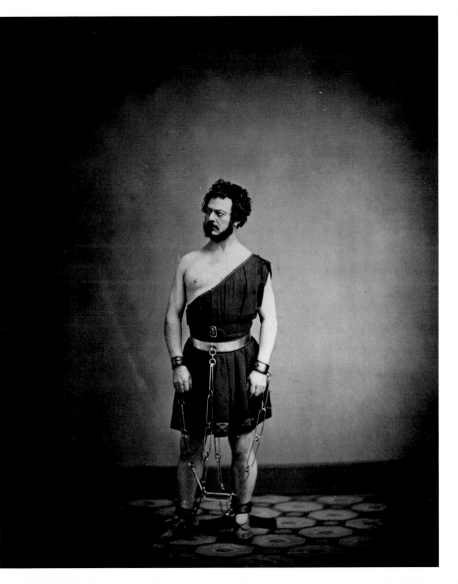

Winfield Scott (1786–1866), New York, 1861. From his first heroic victory in the War of 1812, Winfield Scott enjoyed over four decades of fame, and Brady made his portrait many times in many forms — a daguerreotype in the 1840s, a lithographed print in the 1850s, a carte-de-visite in the 1860s and an Imperial print, shown here. This portrait was made in 1861, only weeks before Lincoln asked Scott to give up leadership of the Union Army in favour of a younger man. Brady often used this setting to photograph military figures before the Civil War forced him onto the battlefield. He clearly enjoyed making portraits of soldiers, whose gilded uniforms, shining boots and imposing swords allowed him to achieve effects found in European paintings of royalty.

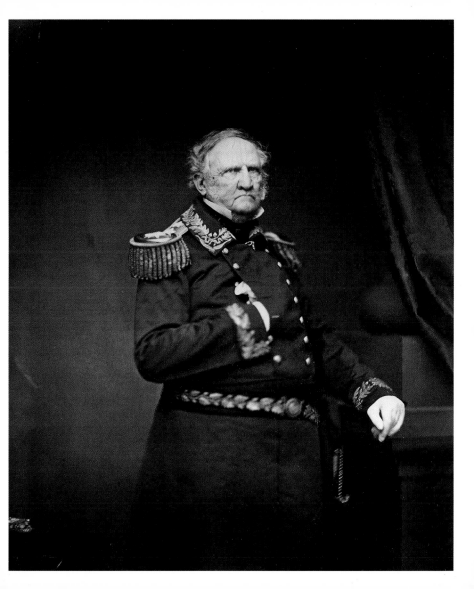

Gerrit Smith (1797–1874), New York, 1861. Gerrit Smith was a widely known philanthropist and social reformer and the only outspoken abolitionist to serve in the US Senate. Best known for his long and generous support of anti-slavery activists John Brown and Frederick Douglass, Smith also promoted temperance and women's rights. Smith's independence and strong character show up even in this carte-de-visite, where he assumes an unusually energetic, individual pose.

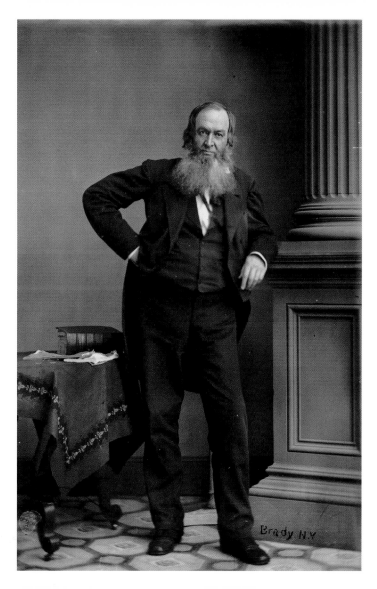

Brady N.Y.

Henry J. Raymond (1820–69), New York, c.1861. Henry Raymond founded the *New York Times* in 1851. A politician as well as an editor, he successfully competed with larger, well-established papers, including the high-minded *Tribune* run by Horace Greeley, and the scandal-laden *New York Herald*, edited by James Gordon Bennett. Newspapermen – the media kings of the time – were among Brady's favourite subjects. In turn, his galleries received frequent and appreciative reviews.

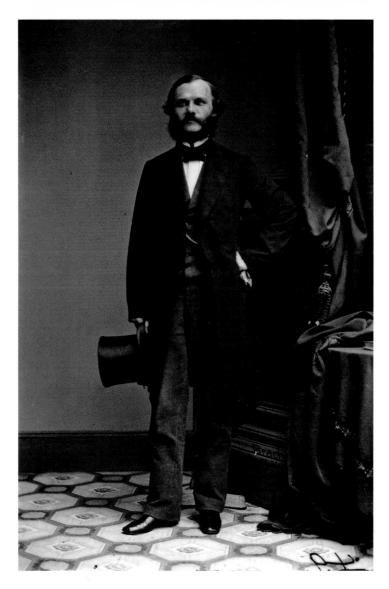

Carl Schurz (1829–1906), Washington DC, 1861. Carl Schurz was forced to leave his native Germany in 1848. He arrived in the United States in 1852 one of many thousands of radical young Germans who came to America in the middle decades of the nineteenth century. Eventually, Schurz turned to politics joining Abraham Lincoln's campaign in 1860 and serving as a general during the Civil War. He later worked as journalist for both English and German language newspapers.

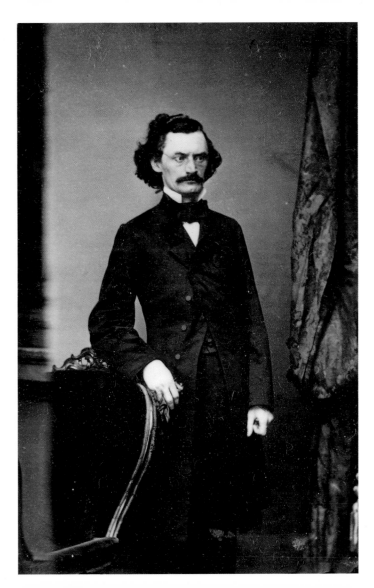

Richard Vaux (1816–95), Washington DC, 1861. A prominent politician and former mayor of Philadelphia, Vaux was especially well known for his interest in prison reform. He was Governor of the Eastern State Penitentiary in 1842, when Charles Dickens visited Philadelphia especially to see the structure. Here prisoners lived in isolation, under constant surveillance – conditions designed to promote reflection and inner reform.

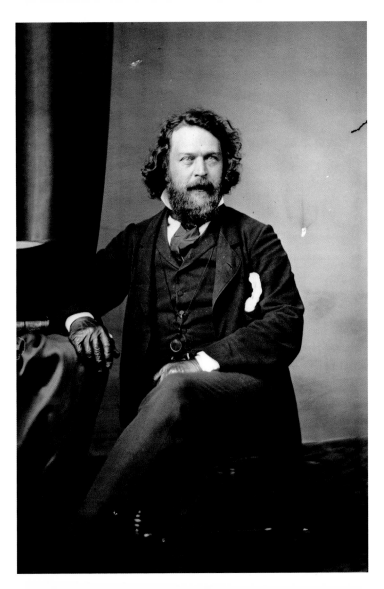

Samuel F.B. Morse (1791–1872), Washington DC, 1861. Morse is now most famous for his invention of the dot-and-dash code used to transmit telegraph messages, but he spent most of his life straining to support himself as an artist. Brady met Morse in New York in the early 1840s, where he made daguerreotypes and taught others to use the camera while teaching art to young painters and sculptors, and continuing to work on the invention that finally made him rich. Many of Brady's sitters posed in this elaborate chair, easily recognized as one designed for the reopening of the US Capitol in 1859.

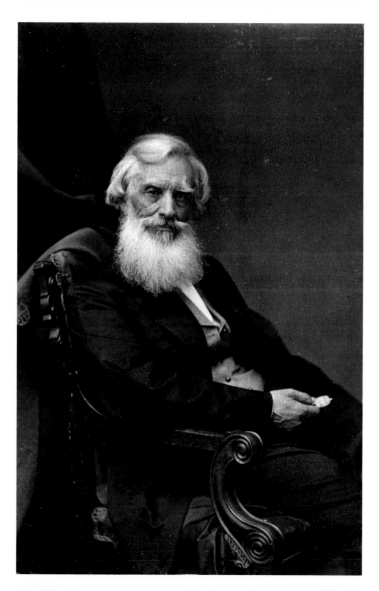

Mary Todd Lincoln (1818–82), Washington DC, 1861. Mary Todd met Abraham Lincoln in Springfield, Illinois, where he practised law. They married in 1842 against her family's wishes. After they reached the White House, Mrs Lincoln became the subject of endless criticism. Her Southern roots, extravagant taste, elaborate clothes and hot temper made her an unpopular First Lady. Nevertheless, her portrait was in great demand, and Brady photographed her on many occasions.

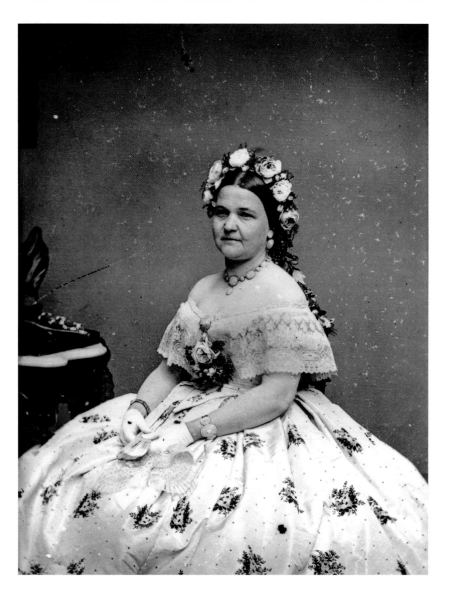

Alexander Shaler (1827–1911), Washington DC, 1861? This jaunty portrait of Alexander Shaler was probably made early in the war. It would have grown in value as Shaler distinguished himself in many notable battles including Antietam, Gettysburg, Wilderness and Spotsylvania. Near the end of his life, Shaler earned a Presidential Medal of Honour for gallantry at Fredericksburg in 1862, a battle best remembered for its huge Union losses, which press and public blamed directly on Lincoln, calling him 'ignorant' and 'incompetent'. The President responded, 'If there is a worse place than Hell, I am in it.'

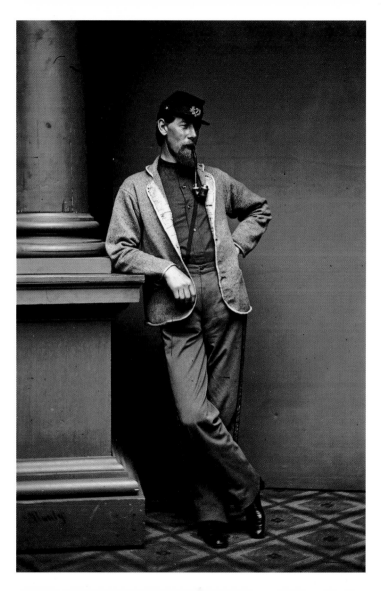

Caroline Richings (dates unknown), New York, c.1861. Sometime in the 1860s, Brady sold his carte-de-visite negatives to the publishing firm of Edward and HT Anthony, who issued millions of these portraits under Brady's name. Around the turn of the century, American antiquarian Frederick Hill Meserve acquired the negatives, which his family later sold to the Smithsonian's National Portrait Gallery. Carte-de-visite portraits of ordinary men and women, like Caroline Richings, demonstrate the firmly democratic nature of this format, which placed all sitters in the same spare environment, regardless of rank, class or fame.

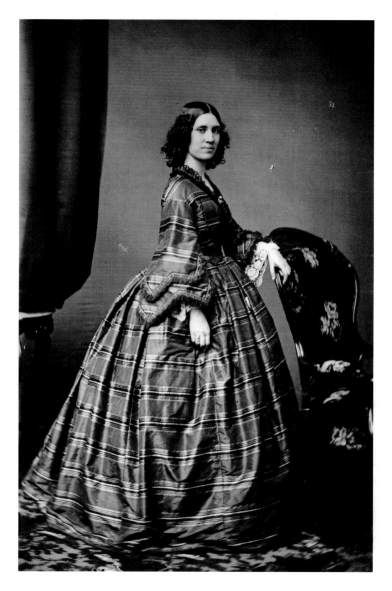

Elmer Ellsworth (1837–61), Washington DC, 1861. Illinois lawyer Elmer Ellsworth aspired to military greatness. Soon after war broke out, he joined the Union army, and was stationed in the occupied town of Alexandria. Ellsworth's zealous destruction of a Confederate flag provoked a skirmish that ended in his death, making him the first Union casualty of the war. Like many soldiers, before he left Washington, Ellsworth posed in uniform at Brady's gallery and chose the new, small, inexpensive style of card portrait, the carte-de-visite. After his death, Ellsworth's portrait became part of many wartime collections. Brady's photographers continued to make portraits of ordinary soldiers throughout the war, doubtless hoping to capture the face of another accidental hero.

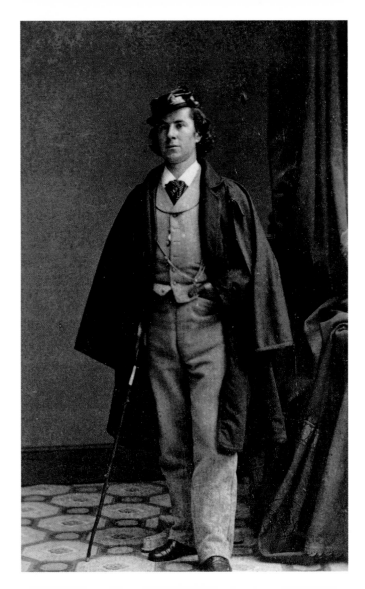

Circassian Beauty, New York, c.1861. Mathew Brady worked closely with show-man P.T. Barnum, whose 'Museum' of marvels stood opposite Brady's first New York studio on Broadway. Barnum's success came from a sharp understanding of the way in which publicity could lure anyone to see just about anything, though his acts also included such authentic performers as Swedish opera star Jenny Lind. To create his mysterious 'Circassian Beauties', Barnum dressed frizzy-haired girls in harem outfits. Between shows, his performers occupied stalls in the museum, where they earned extra money selling their portraits, made by Brady.

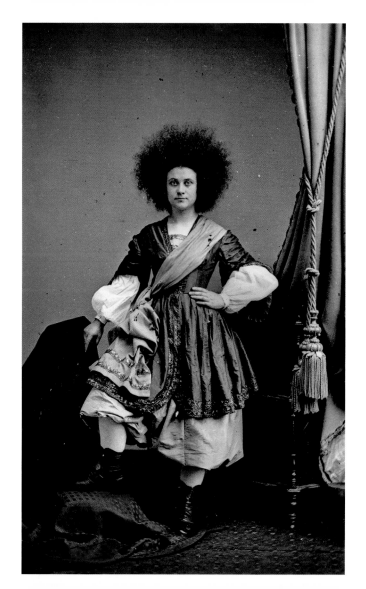

Nathaniel Hawthorne (1804–64), Washington DC, 1862. In 1862, novelist Hawthorne interviewed President Lincoln for the *Atlantic Monthly*. Like any good tourist, he also stopped at the Capitol, Willard's Hotel and Brady's studio, where he posed for a carte-de-visite. The famous author's portrait would have been a valuable (and saleable) addition to Brady's collection. But his frozen pose also betrays a diminished effort on the part of Brady's operators, who clearly found the format too small to display the subtle expression and artistic effects that appear in the larger Imperials.

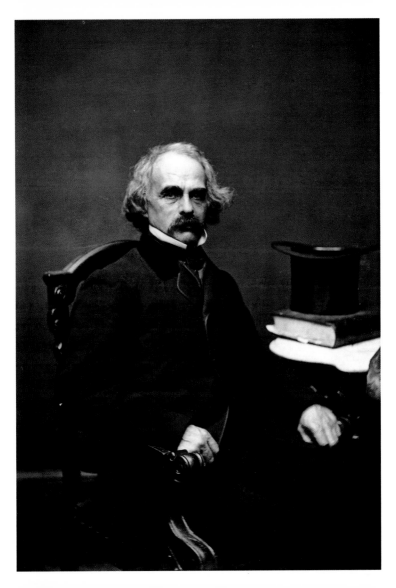

Edwin Booth (1833–93), Washington DC, 1864. A well-loved member of a famous theatrical family, Shakespearean actor Edwin Booth was called 'the ideal of romantic tragedy', whose acting was like 'a spell from which you cannot escape'. He left the stage in 1865, after his brother John Wilkes Booth assassinated Abraham Lincoln, but audience demand caused him eventually to resume his acting career. Brady made an extraordinary effort to pose and light Booth's slender dark figure. As a result, he overcomes the limits of the small carte-de-visite, and successfully conveys the actor's great charisma.

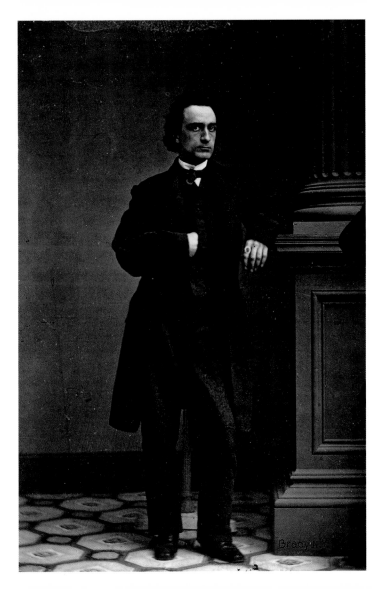

Pauline Cushman (1833–93), New York, 1864. As a popular actress, Pauline Cushman was welcome everywhere in war time, even behind Confederate lines, where she pretended to search for her (fictional) brother, while gleaning important information for the Union Army. Eventually she was caught, imprisoned and finally freed. Cushman poses in a uniform of her own design, which she wore during the successful national lecture tour that followed her espionage career. Performers often commissioned their own carte-de-visite portraits to use for publicity and to sell on the road.

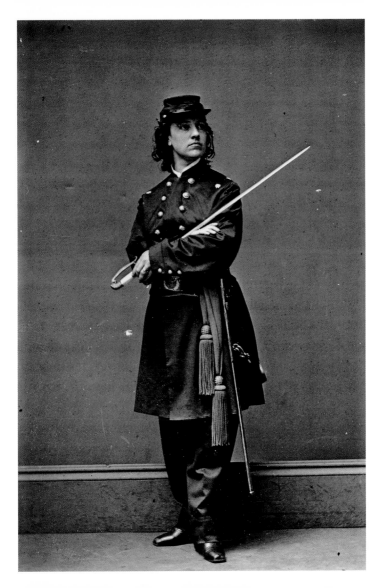

Hole in the Day, Chippewa Chief (dates unknown), Washington DC, 1864. In 1864, Hole in the Day negotiated with the US government on behalf of the Chippewa tribe. Thanks in part to his skill as a negotiator, he received guaranteed protection of new territory, reparations for damage to Chippewa property, new farm equipment, new roads, a sawmill and cash to enable the tribe to clear and cultivate their new land. In many ways, this image demonstrates the sturdy, adaptable qualities of the carte-de-visite, which easily accommodates this long-haired Chippewa chief within the same pictorial format used to portray presidents, emperors and society matrons.

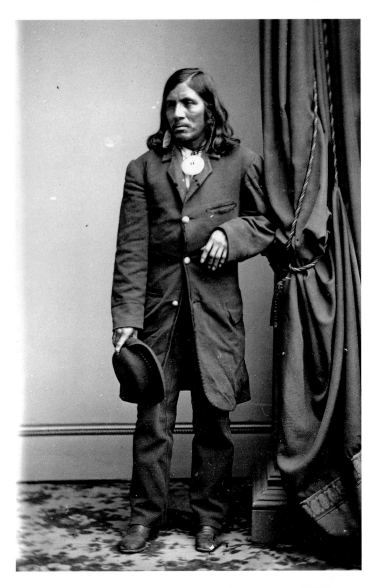

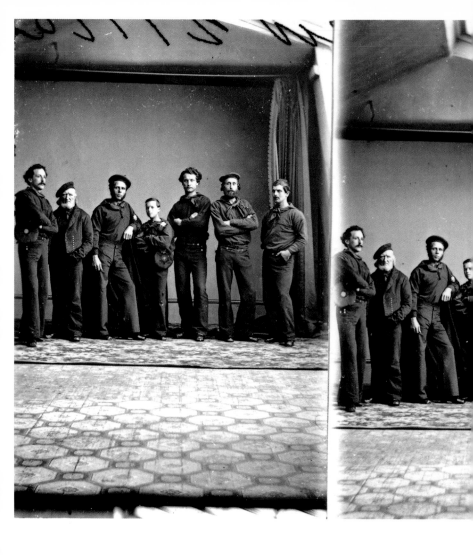

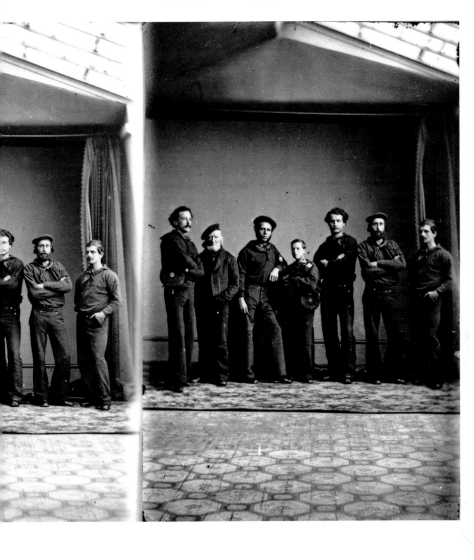

(previous page) Russian Atlantic Squadron, New York, 1863. In September 1863, Russia demonstrated its naval prowess by sending two fleets to America; one sailed for New York, the other for San Francisco, and they reached their destinations almost simultaneously. Members of the Atlantic Squadron posed in Brady's Gallery, probably for a woodcut in an illustrated newspaper. Today, only the negative survives, showing details that would have been cut away, including a rare view of the studio's enormous skylight.

Brady's Photographers and their Wagon, location unknown, US, 1861–5. This image shows one of the darkroom wagons that Brady's photographers took to the field. One can see the dark tent and the wooden boxes bearing Brady's name. These held supplies used to prepare the glass negatives that had to be exposed while the emulsion was still wet. Printing was done in Washington, or some central post well behind the lines. Brady's teams were joined by many other photographers who followed the army with their portable tents, mostly making portraits for soldiers to send back home.

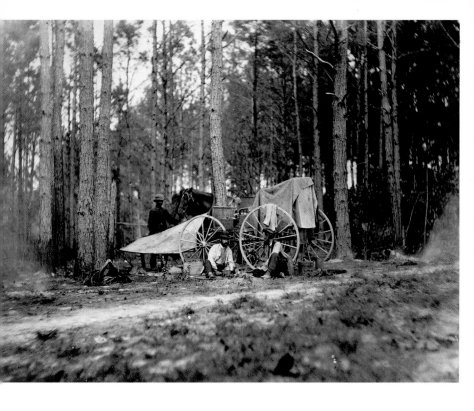

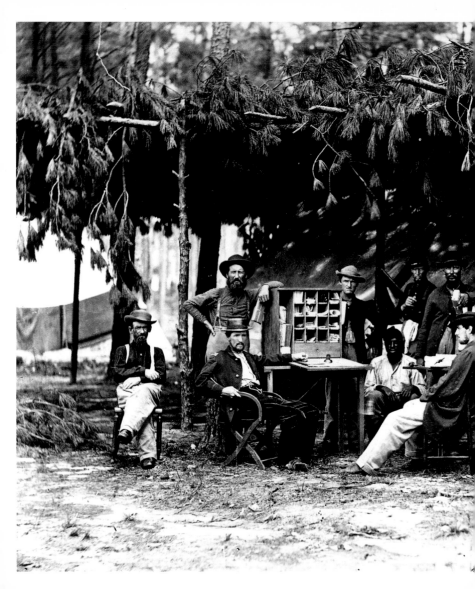

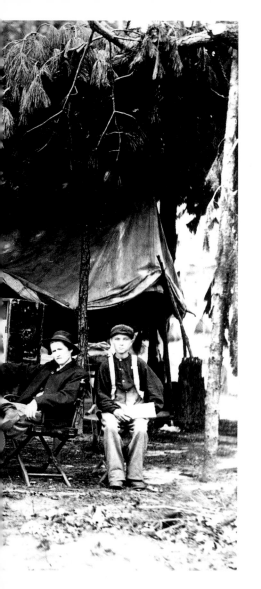

(previous page) Camp of Chief Ambulance Officer, 9th Army Corps, location unknown, US, 1861–5. This careful tableau records the many complex responsibilities of the Ambulance Officer and his staff. It also shows what Brady and his audience expected from a document, and how their view differs from our own. The composition they found dignified and truthful, now seems too theatrical to win our trust. This image provides the kind of information that Brady believed artists would find valuable when they came to represent the war for future generations. Ironically, Brady did not aid these artists, he replaced them.

Twenty-second New York State Militia, near Harper's Ferry, Virginia, 1861. The greatest part of Brady's Civil War documents are portraits of soldiers. This early image shows how his operators struggled to work in the soldiers' camp. Though they successfully replaced studio drapes and tassels with graceful tent flaps and flags, the arrogant, engaging young subjects challenged photographers long accustomed to immortalizing middle-aged celebrities.

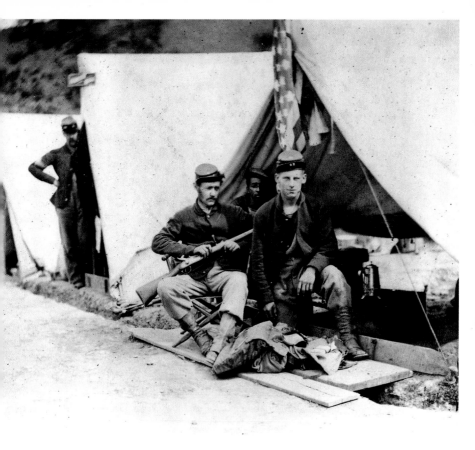

Seventh New York State Militia, Camp Cameron, Washington DC, 1861. Within weeks after the war began in April 1861, this New York brigade came to Washington to help construct the chain of forts protecting the city. Brady began his photographic project by sending operators out to make portraits of soldiers like these, ready customers who spent most of their time in camp a few short miles from his studio.

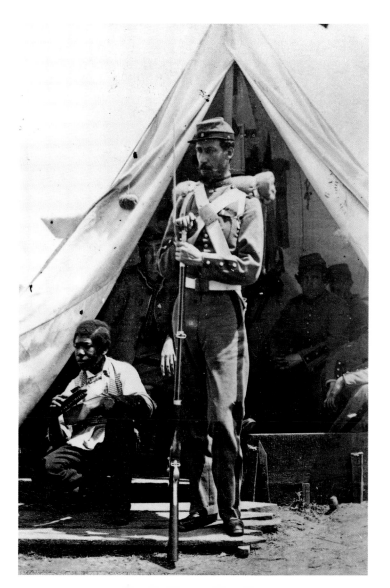

Col. Ambrose Burnside (1824–81) and the Officers of the First Rhode Island Regiment, Washington DC, 1861. After an indifferent military career, Burnside had become a gun manufacturer in Providence, Rhode Island, before he was called back to command a regiment for the Union Army. Lincoln approached Burnside several times in his search for a general to lead the Army of the Potomac, but the general was reluctant and when he finally took command, the army suffered great losses. This cheerful image was made early in the war. Such celebrations provided welcome distraction in camp, and generated optimistic propaganda for Union sympathizers.

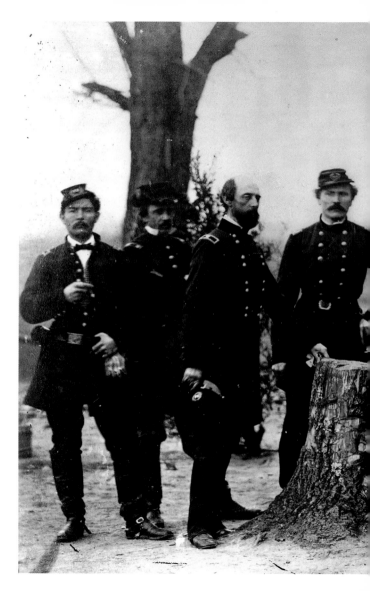

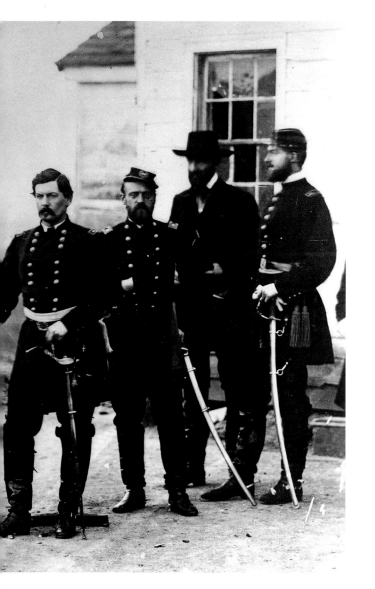

(previous page) George Brinton McClellan (1826–85) and Staff, Virginia, 1862
McClellan became the chief officer of the Union Army in November, 1861, and though he won the lasting affection of his troops, his inability to defeat the Confederate Army soon forced Lincoln to replace him. Brady photographed McClellan and his staff at camp headquarters in Virginia. He posed the group around a tree stump to give the image rough authenticity, but close inspection shows that he also used an iron studio stand to ensure that McClellan's head and shoulders would remain steady. Its telltale cast-iron base appears behind McClellan's feet.

Bodies Near Dunker Church, Antietam, Maryland, 1862. In September 1862 Confederates met Union troops in Maryland for what became the three bloodiest days of the war. Immediately afterwards, Alexander Gardner and a team of photographers documented the carnage in terms that all viewers found shocking. The *New York Times* reported that these images exerted a 'terrible fascination' and credited Brady with showing, for the first time, 'the terrible reality and earnestness of war ... he has ... brought bodies and laid them in our door-yard and along the streets'. Gardner soon left Brady to establish his own business and his photographers produced some of the war's harshest and most memorable images. Brady, true to his romantic vision, recorded battlefields only after the corpses were gone.

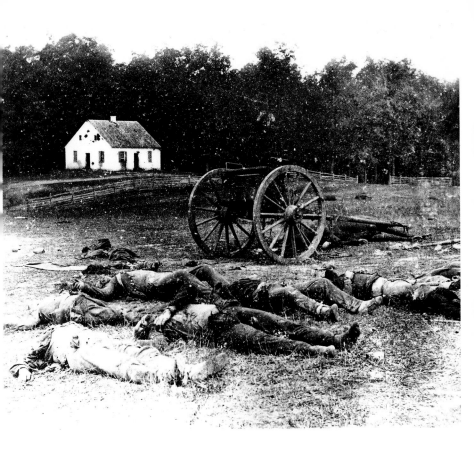

Fort C.F. Smith, Virginia, 1863. During the Civil War, the City of Washington was protected by a chain of thirty-four temporary and permanent encampments, among them Fort Smith, which was one of the largest, and newest, with space for twenty-two guns. This photograph was made around 1863, when the fort opened. Here, the soldiers pose with a casual charm that rarely appears in Brady's portraits of officers.

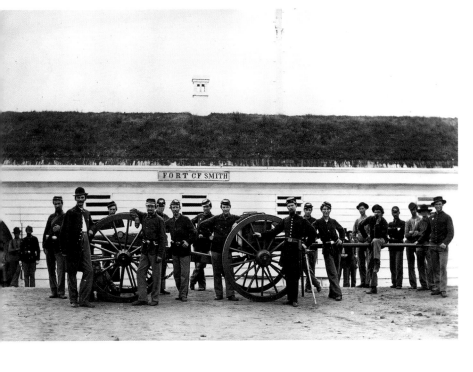

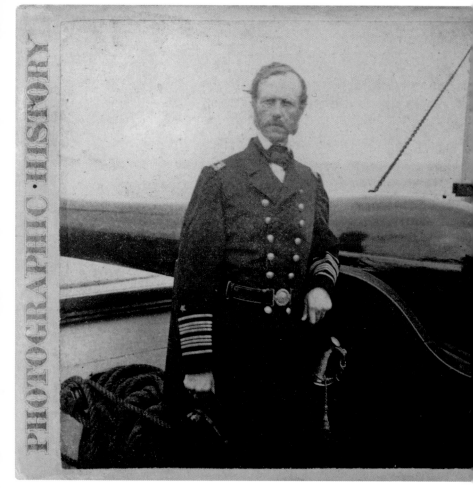

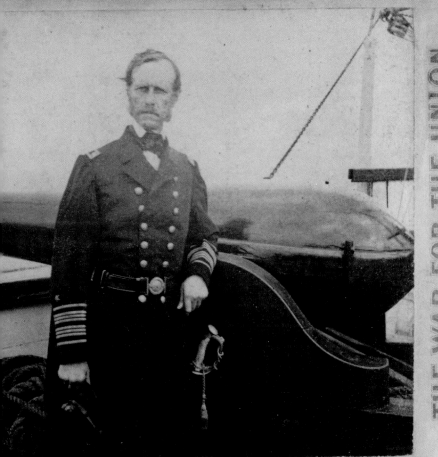

(previous page) Admiral John Dahlgren (1809–70), Charleston, 1863–5.
A career officer in the Navy, Dahlgren took command in 1861 when his chief resigned to lead the Confederate Navy. Dahlgren was known around the world as the inventor of a light, accurate cast-iron gun, which appears in the background of this stereograph. This form of photography produced a three-dimensional illusion when seen through a special viewer. Stereographs provided popular middle-class entertainment through the last half of the nineteenth century.

Brigadier General Charles F. Adams, Jr (1835–1915), Virginia, 1864. Despite Brady's reputation for vivid documents of warfare, his operation mostly produced elegant portraits of officers in camp, such as this image of Charles Adams, son of Lincoln's ambassador to England and Commander of the Fifth Massachusetts Cavalry, an African-American regiment that fought at both Gettysburg and Antietam. After the war, Adams became a historian, who wrote with generosity and insight about the bravery of his Confederate adversaries.

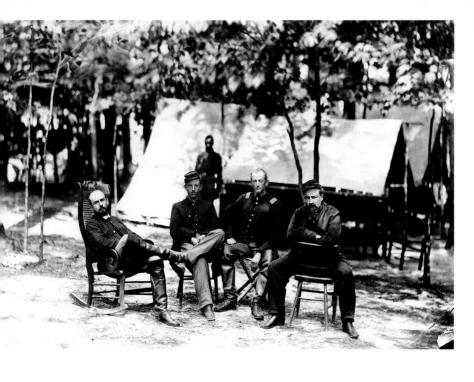

Ulysses S. Grant (1822–85), Cold Harbor, Virginia, 1864. Lincoln appointe
Grant to head the Union Army in 1864 after five other generals had failed t
defeat the Confederate Army. Grant's ruthless campaign lasted thirteen month
and cost tens of thousands of lives on both sides before the war came to an en
in the spring of 1865. Brady photographed Grant in camp, where his aler
stance bears little resemblance to the conventions of the carte-de-visite studic
Altogether, the portrait reveals Grant's modern disregard for worn-ou
conventions – military as well as artistic.

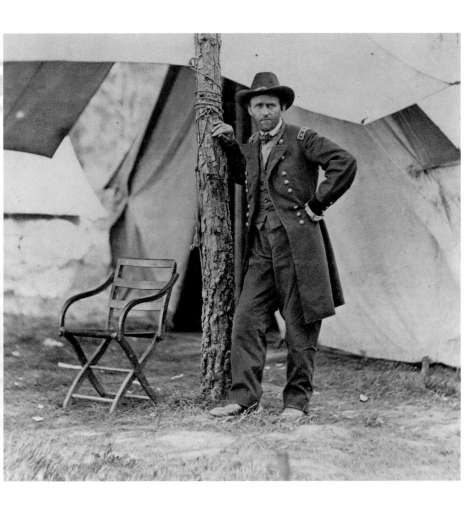

General Philip Henry Sheridan (1831–88), Virginia, 1864. Under Grant, in the summer of 1864, Sheridan oversaw the destruction of the Shenandoah Valley, the rich region from which the South had drawn most of its food and supplies. One memorable night, he rode twenty miles to lead a victorious surprise attack, a feat that inspired many patriotic poems and pictures. This portrait shows how Brady's operators used the standard features of an officer's camp to frame their subjects, tent flaps replacing studio drapes. Behind Sheridan, a soft blurred figure suggests the deep space that surrounds him, and the camera's automatic accumulation of environmental detail gives this dashing, romantic image the power of 'truth'.

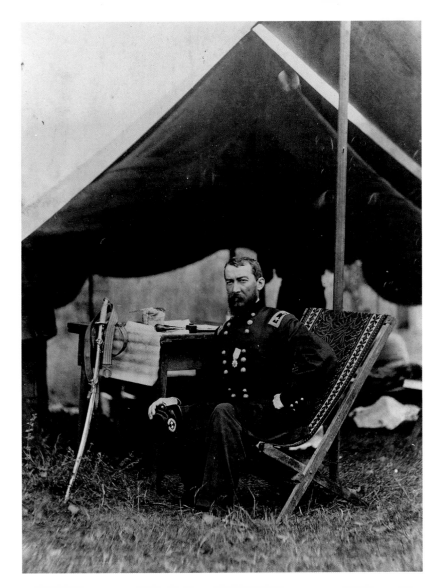

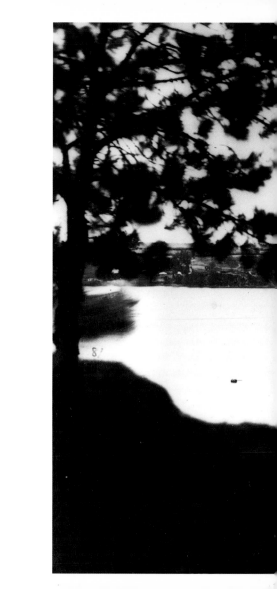

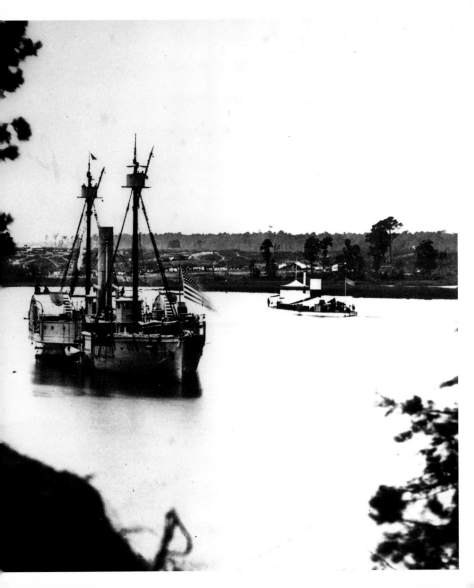

(previous page) US Gunboat Agawan on the James River, Virginia, 1864. Brady published countless photographs of famous military sites, like this view of the Union gunboat Agawan on the James river, made in 1864 just outside the Confederate capitol of Richmond. Many such views were published as stereographs, images that formed a vivid three-dimensional illusion when seen through a special viewer. Here, the blurred branches in the foreground would have created the sensation that one observed the boat through the trees on the riverbank. The image was published in a series devoted to 'Grant's Late Campaign'.

Robert E. Lee (1807–70), Richmond, Virginia, 1865. Just before the Civil War began, Lincoln asked Robert E. Lee to head the Union Army, but Lee could not desert his Southern family and instead became Commander of the Army of the Confederacy. For the first two years of the war, Lee's army consistently defeated the Union, despite smaller numbers and dwindling supplies. Even in retreat, his troops withstood Grant's relentless pressure for many months before the final surrender at Appomattox in 1865. Brady photographed Lee in Richmond shortly after the war ended. To those who questioned the value of a portrait of a losing general, Brady replied that this 'would be the time for the historical picture'.

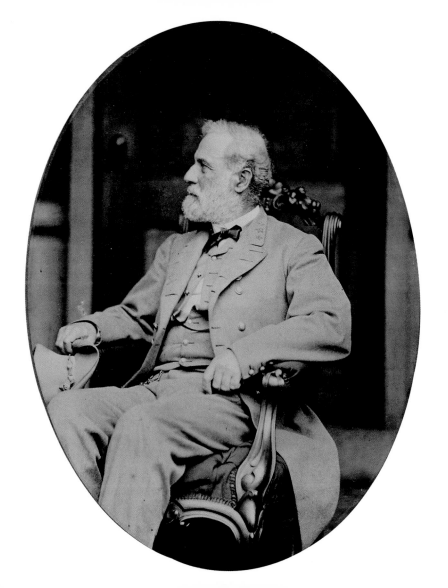

Sherman (1820–91) and his Generals, Washington DC, 1865. In 1864, General William Tecumseh Sherman approached the Confederate capital of Richmond by leading a campaign across the south. Sherman's march across Georgia became legendary for its merciless destruction of all resources, military and civilian. In 1865, Brady gathered Sherman and his generals for a last commemorative portrait, but one man failed to appear. Later, Brady completed the group by adding a photograph of the missing man to the space he left on the right edge of the frame, then photographed the composite to create a photograph that matched the caption.

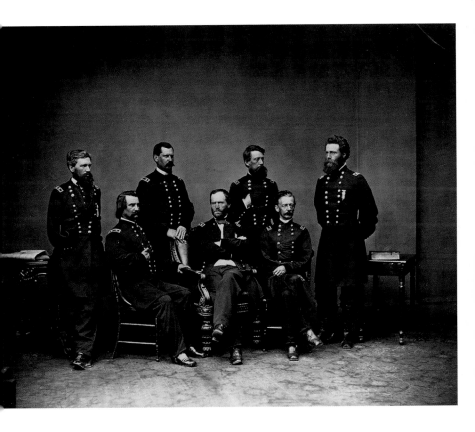

The Battle Field of Gettysburg, Gettysburg, Pennsylvania, 1863, republished 1865. Brady made his photographs for posterity, for those who would know the Civil War 'only through the purple haze of history'. Here, the leafy trees, winding fence and the small figure of Brady himself reflected in the water, declare his artistic aspirations. Ironically, Brady's photographs helped destroy the romantic vision of war he hoped to support. But at the end of the nineteenth century as a new generation searched for views of the past, Brady triumphed when his photographs took the place of memories and the glorious history he imagined became real.

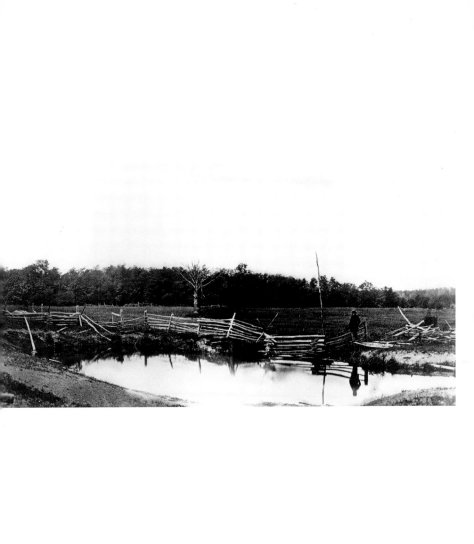

1823 Born near Lake George, Warren County, New York. Exact date not known.

1839 Arrives in New York City and is introduced to Samuel Morse, who teaches daguerreotype-making and portrait painting while simultaneously developing a code for telegraph.

1844 Opens first portrait studio making daguerreotypes, Daguerrean Miniature Gallery, on Broadway.

1845 Begins collecting portraits of important Americans.

1846 His daguerreotype portraits of prisoners are used to illustrate the US edition of *Rationale of Crime*, by British phrenologist Marmaduke Sampson.

1849 Visits Washington D C for the inauguration of President Zachary Taylor. Tries, unsuccessfully, to open a studio and returns to New York.

1850 Publishes *Gallery of Illustrious Americans* with lithographed copies of daguerreotypes. Project ends after twelve issues. Around this time he marries Juliette Handy in Washington D C.

1851 His daguerreotypes are included in US national display at the Great Exhibition, London. Receives a medal for excellence. Spends the next ten months in Europe.

1853 Opens a new studio on Broadway, Brady's National Portrait Gallery.

1856 Hires Scottish photographer Alexander Gardner. Exhibits coloured photographs on paper and canvas.

1857 Woodcut copies of his portraits are published in *Harper's Magazine*. Exhibits 'Imperial' photographs (24 x 20 inch) and life-sized photographs, five by seven feet. Employs twenty-six operators, artists and salesmen.

1858 Opens studio in centre of Washington D C.

1860 Opens a third studio in New York. Photographs Abraham Lincoln at

the beginning of his presidential campaign, and Edward, Prince of Wales on first British royal visit to US.

1861 Civil War breaks out 12 April. Sends teams of photographers to the forts and camps to make photographs.

1862 While working for Brady, Gardner photographs bloody battlefields in Antietam. These photographs are exhibited in New York and gain much public attention. Gardner leaves to establish his own independent studio.

1866 After end of Civil War, he begins a series of unsuccessful efforts to sell archive of thousands of photographs and negatives despite endorsement from General Grant and prominent artists.

1873 Files for bankruptcy and closes New York studio. Becomes official resident of Washington D C.

1875 US War Department purchases large collection of negatives and prints for $25,000.

1881 Closes Washington studio.

1882–1893 With his nephew and partner Levin Handy, he operates a succession of new studios in Washington D C.

1887 20 May, Juliette Handy Brady dies.

1895 He is injured in a streetcar accident in Washington D C.

1896 16 January, dies in New York and is buried in Congressional Cemetery Washington D C.

Photography is the visual medium of the modern world. As a means of recording, and as an art form in its own right, it pervades our lives and shapes our perceptions.

55 is a new series of beautifully produced, pocket-sized books that acknowledge and celebrate all styles and all aspects of photography.

Just as Penguin books found a new market for fiction in the 1930s, so, at the start of a new century, Phaidon 55s, accessible to everyone, will reach a new, visually aware contemporary audience. Each volume of 128 pages focuses on the life's work of an individual master and contains an informative introduction and 55 key works accompanied by extended captions.

As part of an ongoing program, each 55 offers a story of modern life.

Mathew Brady (1823–96) was the leading portraitist of his day. His willingness to adopt new technology and his flair for publicity helped turn his studio into a tourist destination. At the outbreak of the Civil War, Brady sent a corps of photographers to record the soldiers, generals and battle scenes, thereby linking himself and his subjects to a heroic national narrative.

Mary Panzer is a historian with a special interest in American photographs. She was Curator of Photographs at the National Portrait Gallery, Smithsonian Institution, in Washington DC from 1992–2000.

Phaidon Press Limited
Regent's Wharf
All Saints Street
London N1 9PA

Phaidon Press Inc.
180 Varick Street
New York NY 10014

www.phaidon.com

First published 2001
©2001 Phaidon Press Limited

ISBN 0 7148 4065 3

Designed by Julia Hasting
Printed in Hong Kong

Photographs by permission of The Library of Congress, Washington DC, and The Smithsonian National Portrait Gallery, Washington DC.